ORPINGTON & AROUND
HISTORY TOUR

First published 2017

Amberley Publishing
The Hill, Stroud,
Gloucestershire, GL5 4EP
www.amberley-books.com

Copyright © Phil Waller & Tom Yeeles,
2017
Map contains Ordnance Survey data
© Crown copyright and database right
[2017]

ISBN 978 1 4456 5713 4 (print)
ISBN 978 1 4456 5714 1 (ebook)

British Library Cataloguing in
Publication Data.
A catalogue record for this book is
available from the British Library.

Origination by Amberley Publishing.
Printed in Great Britain.

INTRODUCTION

Modern Orpington and its district, as we know it, has not yet reached its centenary. The history of Orpington, however, goes much further back. Generations of local historians have enjoyed and spent countless hours researching and recording information and pictures using the available methods of the day to show their work to anyone who might be interested. The sharing of their knowledge with others often took the form of local publications, talks in village halls and exhibitions at larger local events. The enthusiasm and need to research has not really changed, but the use of modern technology to find out more and the ability to share their findings more widely has. Philip Waller, author of *Around Orpington Through Time*, brought two of his hobbies together to establish the online Orpington History Organisation (OHO). A native of Orpington, he has a keen interest in local history going back nearly twenty-five years, combined with success in running large online internet-based communities and groups.

The Orpington History Organisation (www.orpington-history.org) began with a website page offering a detailed timeline, a collection of hundreds of pictorial items and a very successful social media channel. This initial beginning was embraced and expanded by the interaction of enthusiasts who became an integral part of the organisation in terms of contributions, both verbally and through pictorial submissions. The purpose of the OHO was to fill a gap on the internet with the objective to share a good portion of its collection, display articles and generate interaction. Since its creation in 2006, the OHO has gone from strength to strength with its extremely popular website, talks and exhibitions and huge international following on Facebook and Twitter. The Orpington History Organisation is also proud to be a founding member of the Bromley Heritage and Arts Forum and is listed in the Bromley Historic Collections pamphlet.

All old images, apart from those credited throughout the book, are part of the Orpington History Organisation Collection.

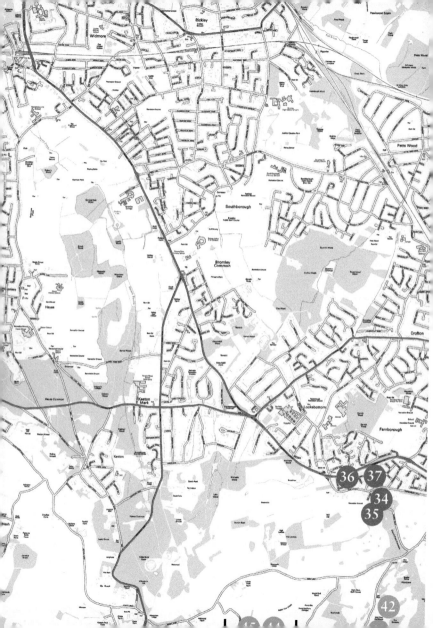

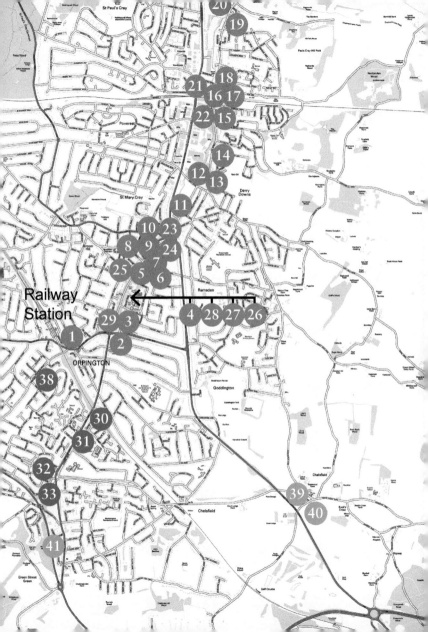

KEY

Tour One

Orpington Railway Station, 1927

1. The Maxwell Arms/Hotel, Station Road
2. Gravel Pit Cottages
3. The Commodore Cinema
4. Mayfield Place
5. E. J. Elton Butcher
6. All Saints Church
7. The Priory
8. Chislehurst Road School
9. Rose Cottage
10. Smith and Milroy Garage
11. St Andrews Church
12. Vanguard Bus Funeral Procession
13. Reynolds Cross
14. The Temple Church
15. St Mary Cray High Street, Looking North
16. St Mary Cray Railway Viaduct
17. St Mary the Virgin Church
18. St Mary Cray High Street, Looking South
19. St Paulinus Church
20. Main Road, St Paul's Cray
21. Joynson's Paper Mill
22. Morphy Richards Factory
23. Carlton Parade
24. The Priory Ponds
25. The Artichoke
26. Village Hall
27. The Old Cottages
28. Coach & Horses
29. War Memorial

Tour Two

30. Boundary Garage and SE Railway 'Triumph Arch'
31. Orpington Hospital
32. The Crescent
33. Farnborough Bypass Crossroads
34. The George & Dragon
35. St Giles Church
36. The Cosy Nook, Farnborough High Street
37. Main Parade, High Street Farnborough
38. W. H. Cook Chicken Farm, Tubbenden Lane

Tour Three:

Further Afield

39. Five Bells, Chelsfield
40. High Street, Chelsfield
41. Fox & Son Oak Brewery, Green St Green
42. High Elms House
43. Clock House Farm, High Elms
44. High Street, Downe
45. Village Pond, Downe

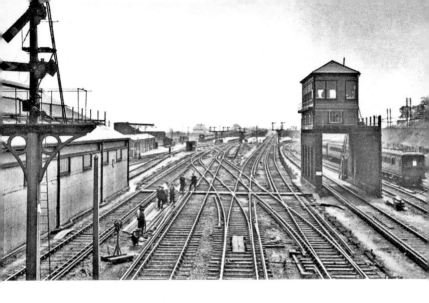

TOUR ONE
ORPINGTON RAILWAY
STATION, 1927

Orpington station will be both the start and end point of this first history tour of the town.

Orpington Station was opened on 2 March 1868, when the South Eastern Railway (SER) opened its line between Chislehurst and Tonbridge. The station is the main reason why Orpington expanded from a medium-sized village to a prosperous expanding town in just over fifty years, and is why some of the suburbs of Orpington are well established despite being not even 100 years old. Today, Orpington Station serves three West End and four City of London stations with 5 million passenger journeys a year.

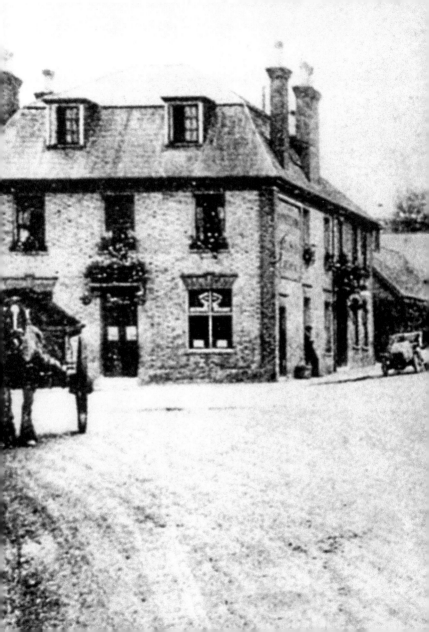

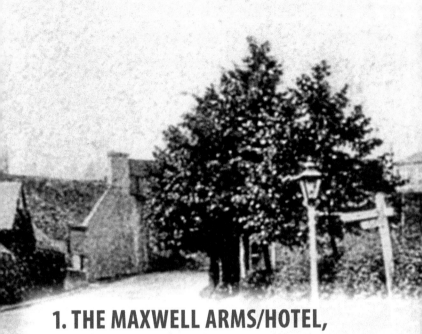

1. THE MAXWELL ARMS/HOTEL, STATION ROAD

Walk south on Station Approach to Station Road/A232. Turn left onto Station Road/A232.

The railway came to Orpington in 1868. At that time, Orpington was a sleepy village surrounded by typical Kent farms producing hops, soft fruit and livestock. The railway would change Orpington forever. Most railway stations were accompanied by public houses, and so the Maxwell Arms was built in 1887. The name comes from one of the last families that resided at Tubbenden House, which was located approximately where Shelley Close is today. (Courtesy of Bromley Local Studies Department)

2. GRAVEL PIT COTTAGES

Walk east (downhill) on Station Road/A232 toward War Memorial Roundabout.

An unfamiliar view before the war memorial and roundabout were built. The view here is looking towards Green Street Green. The cottages on the left were part of Gravel Pit Farm and were demolished when Spur Road was constructed, as part of the Orpington Bypass, in 1926. The turreted building ('Corner House') survived until the early 1980s, when it was demolished to make way for Brasted Close.

3. THE COMMODORE CINEMA

Walk north into High Street (to Nos 291/293 High Street).

Many different establishments provided entertainment in the town, but for years the Commodore Cinema was the preferred venue to watch the latest newsreels and films. Built and opened in 1933 by the Spencer-May family, the cinema was another local landmark. Built with considerable internal and external art deco features, the cinema closed in 1982 and was later demolished after a fire. In 2016 the cinema returned to Orpington with a new Odeon branded multiscreen complex in the Walnuts Shopping Centre.

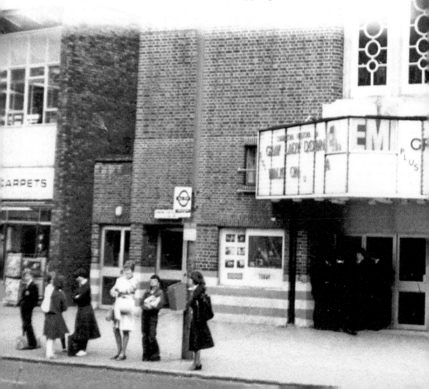

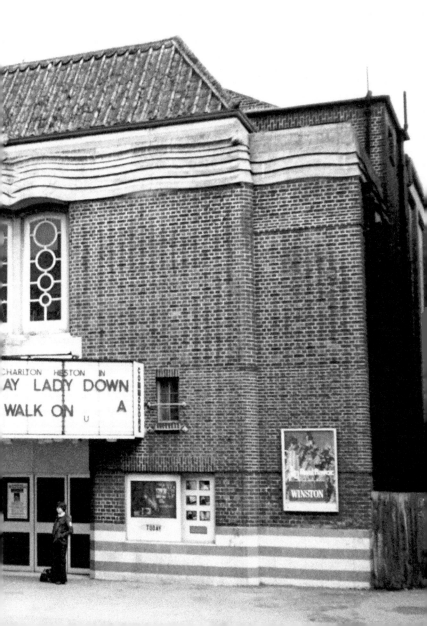

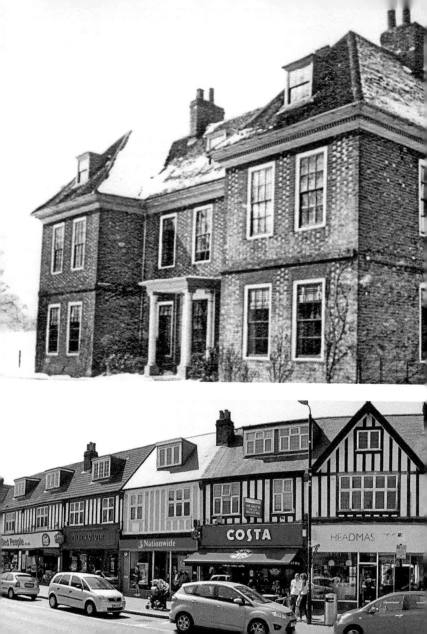

4. MAYFIELD PLACE

Walk north along High Street (approximately to the location of Costa at No. 196 High Street).

Mayfield Place stood magnificently at the centre of the manor of Mayfield, or Little Orpington, for many years. Built in 1750, it survived into the 1930s, well after the Mayfield Estate, farm and title of lord of the manor ceased to exist. A campaign to keep it for use as a municipal building gave way to pressure to develop the High Street for the expanding population of Orpington. Want to learn more about the manor? History on our Doorstep by the residents of Vinson Close is available for purchase at Orpington Library. (Bromley Local Studies Department)

5. E. J. ELTON BUTCHER

Continue to walk north along High Street to No. 124 High Street.

A butcher has traded on this site for a very long time. Mr Edward Elton and his family business were notable in the village and later town. Aberdeen House is the correct name for the building that contains the shop and former dwellings. As they became more prosperous, the Eltons moved into a large house just back from the High Street called Drayton Lodge, which was purchased by the London Borough of Bromley and demolished to make way for the Walnuts Shopping Centre. Elton's started trading from Aberdeen House around 1907 and, as you can see, Majestic Catering are continuing the tradition today.

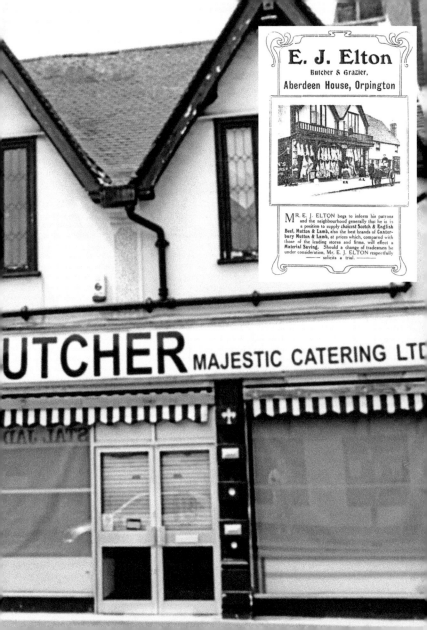

E. J. Elton

Butcher & Grazier,

Aberdeen House, Orpington

MR. E. J. ELTON begs to inform his patrons and the neighbourhood generally that he is in a position to supply choicest Scotch & English Beef, Mutton & Lamb, also the best brands of Canterbury Mutton & Lamb, at prices which, compared with those of the leading stores and firms, will effect a Material Saving. Should a change of tradesmen be under consideration, Mr. E. J. ELTON respectfully solicits a trial.

BUTCHER MAJESTIC CATERING LTD

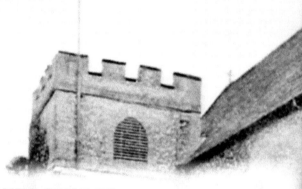

6. ALL SAINTS CHURCH

Walk north-east along High Street past Broomhill Road, at the roundabout turn right into Church Hill (200 feet). Walk up Church Hill past Bark Hart Road and enter the churchyard via Lychgate, then continue up the path to the church.

The parish church of All Saints, Orpington, is the oldest existing building in Orpington. The church has been present on this site for over 1,000 years, standing on pre-Norman foundations. Mentioned in the Domesday Book, some Saxon parts of the church are still visible along with a sundial. All Saints had a spire that was destroyed by lightning strikes twice. In 1957, the church was significantly extended using land gained by the demolition of Bark Hart House. The church is located on a slight hill above Orpington High Street, where an old riverbed is located and would occasionally flood. (Courtesy of Lynn Sculpher Collection)

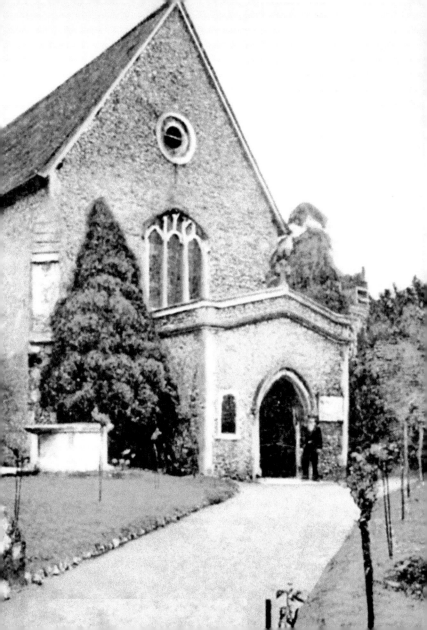

7. THE PRIORY

Walk back down the churchyard path to Lychgate. Walk down Church Hill (230 feet). The entrance to the Priory is on the right, enter and walk for 100 feet and the Priory is on the right.

The Priory, which stands on a former Saxon estate, can be traced back to the late thirteenth century. The priory was an important stop-off and Orpington's rectory for many years. At its core, the priory is a medieval hall house. Considerable thirteenth-, fourteenth- and fifteenth-century architecture is clearly visible, with many impressive interior Tudor examples. In 2016 The Bromley Museum vacated The Priory and V22 (an art organisation) commenced a 125 lease, and plan to open in mid-2017.

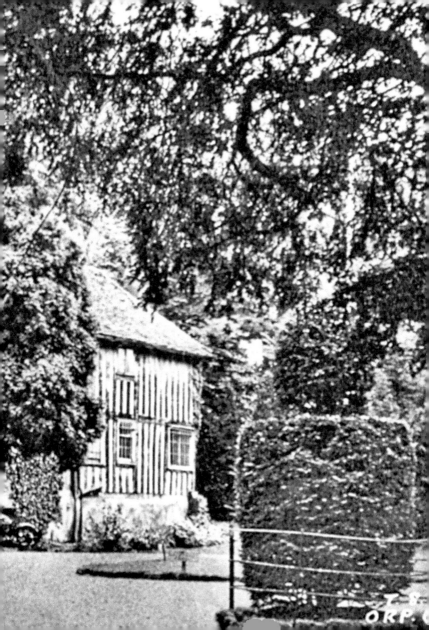

8. CHISLEHURST ROAD SCHOOL

Locate Aynscombe Angle entrance (approximately 100 feet to the west of the Sunken Gardens). Walk along Aynscombe Angle (358 feet) to High Street. Turn left and then immediately right into Moorfield Road. Walk along Moorfield Road (404 feet) and turn right into Elmcroft Road (49 feet).

Before 1870, children only went to school if their parents could afford it or a wealthy benefactor provided the education. Education boards were established under the 1870 Education Act as part of the local authority changes in Victorian Britain. The board existed to ensure that education was available to all. The 'Board School', Chislehurst Road, was built in 1882 and extended in 1897 and was Orpington's first purpose-built school for all. (Courtesy of Colin Churcher)

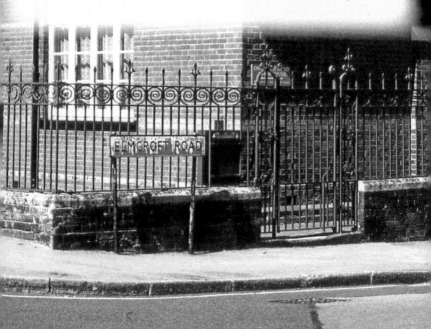

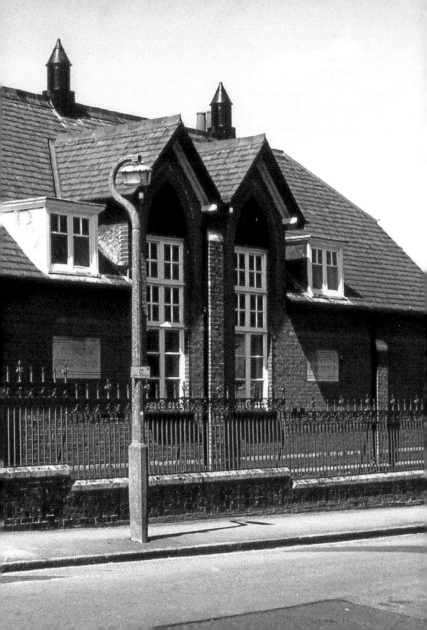

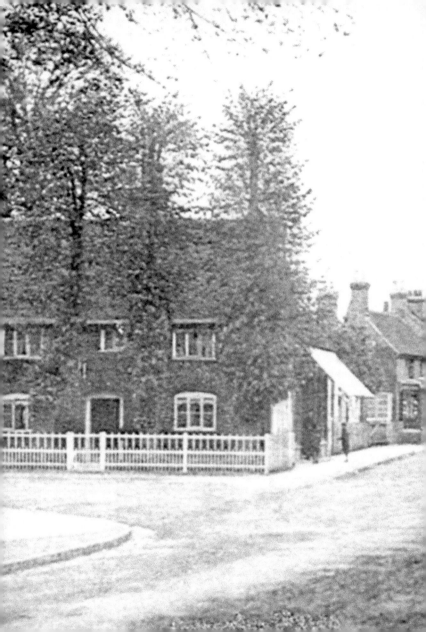

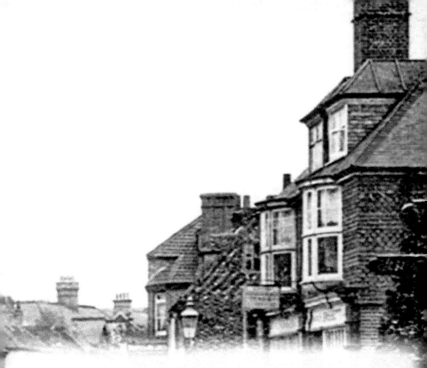

9. ROSE COTTAGE

Walk north-east on Elmcroft Road towards Chislehurst Road/A223 (223 feet). Turn right into Chislehurst Road/A223 (315 feet).

This is the junction of the High Street and Chislehurst Road, which in those days was the main road junction into and out of the village. On the north corner is the Limes or Rose Cottages, which were built in 1690 and for centuries would have been well known and instantly recognisable. Popplewells was a drapers shop at the back of the Limes, established by Mr John Popplewell, son of Joseph, the principal teacher at the British School. The Limes and what was left of Popplewell's shop became run down and were demolished in the 1970s.

10. SMITH AND MILROY GARAGE

Turn left at the junction with High Street and continue north until the junction of Perry Hall Road.

The Orpington Car, built by Frank Smith and Jack Milroy at their works in Wellington Road (although the image here shows their works at the northern end of Orpington High Street opposite the priory pond), was shown at the 1920 Motor Show. It was a two-seater convertible, with a dickey seat and a 10-horsepower 7-kw engine. Although briefly successful, the last car was built in 1925. The only known survivor once appeared in the 1970s television series *Crossroads*. A recent publication, to which the Orpington History Organisation contributed images and information, is available. For further information please see www.theorpingtoncar.co.uk.

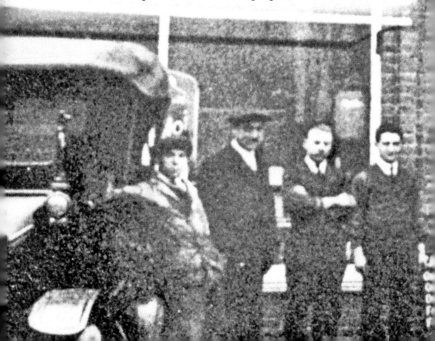

11. ST ANDREWS CHURCH

Continue along High Street to the busy Carlton Parade junction (0.1 miles). Cross over the junction and into Lower Road and continue for 0.1 miles.

St Andrews was built and opened in 1893 on Lower Road to support the stretched-to-capacity parish church of All Saints, Orpington. St Andrews initially took its congregation from the residents of New Town. However, the next wave of development was taking place to the north-east of Orpington on the former land of Northfield Hall, and St Andrews' congregation boomed. Although St Andrews started as an extension of All Saints, it became a parish church in its own right in 1935.

12. VANGUARD BUS FUNERAL PROCESSION, KENT ROAD

Walk north-east along Lower Road (0.2 miles). Turn right at the mini-roundabout into Kent Road (79 feet).

A tragic end to a trip to Brighton for members and friends of the Crays and Orpington Volunteer Fire Brigades. Just before 11 a.m. on Thursday 12 July, the brakes of the hired Vanguard bus failed on the steep descent to the village of Handcross in Sussex. Ten were killed, six instantly, including Henry Hutchings, an undertaker. The funerals, held over three days, attracted huge gatherings and 3,000 attended that of Mr Hutchings. This postcard shows his cortège leaving St Mary Cray for All Saints' Church in Orpington. This was the world's first bus disaster and is now just a footnote in history books and a regularly mistitled postcard on eBay.

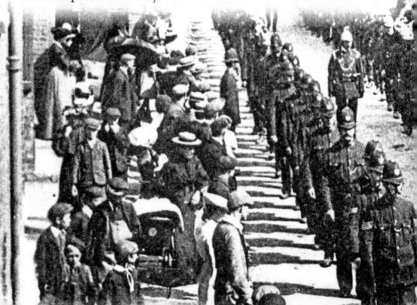

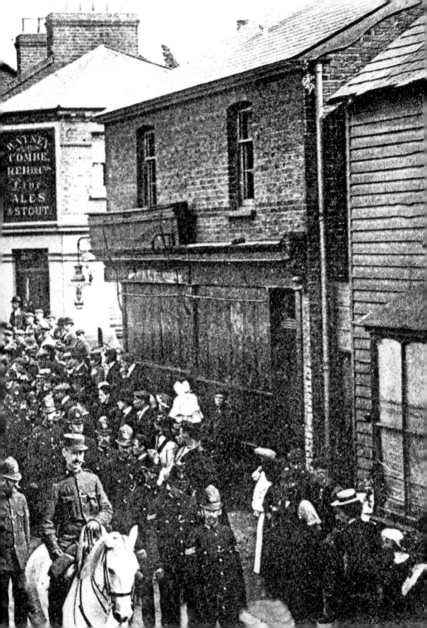

13. REYNOLDS CROSS

Continue along Kent Road (south-east) to the mini-roundabout (340 feet).

This was the main junction with St Mary Cray High Street. It has been known as Reynolds Cross, after Reynold Smith who had a nearby smallholding for well over 100 years. Coaches left here daily at 8 a.m. for Greenwich and the London & Greenwich Railway, which was the district's nearest rail link to the city. Many photographs were taken of this place for postcards and almost all of them have a policeman from the local St Mary Cray Police directing traffic. Until the bypass was built, this was a very busy junction.

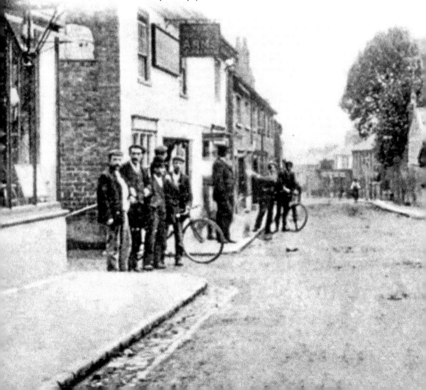

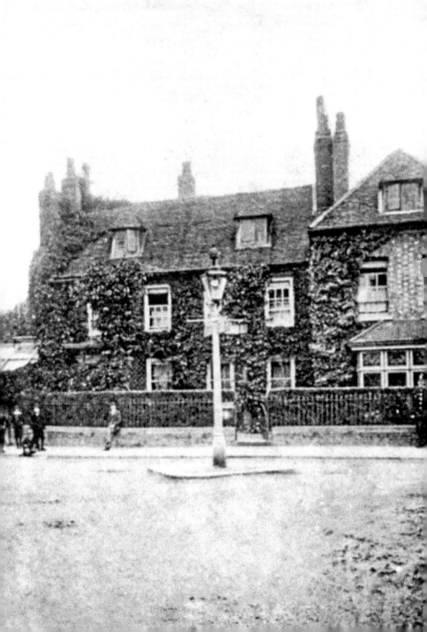

14. THE TEMPLE CHURCH

Walk north along High Street for approximately 0.3 miles.

The Temple United Reformed Church has been part of the community of St Mary Cray for well over 150 years. It was William Joynson of Joynson's Paper Mill who contributed a huge amount of money to build the church (built in 1851) and Moffat Hall (built in 1891). The former main church building was hit by a parachuted landmine in 1941 and the structure was irreparably damaged. By 1950, it was considered unsafe and had to close. A new church was built and reopened in 1955, and it continues to serve the community to this day. (Courtesy of Lynn Sculpher Collection)

15. ST MARY CRAY HIGH STREET, LOOKING NORTH

Walk north along High Street, straight over the mini-roundabout and continue to where the road splits. Stay right to remain on High Street (0.2 miles).

A view looking north along St Mary Cray High Street. Many older buildings still remain, but sadly some do not. Traffic has been diverted from this side of the viaduct (as it has the north side), giving a very subdued existence, which is in complete contrast to how things would have been 100 years ago. You have to imagine a time when St Mary Cray was the market town of the district – it had industry in mills and foundries, and was reached by the railway before Orpington.

16. ST MARY CRAY RAILWAY VIADUCT

Turn right into Mill Brook Road/B258 and continue to Railway Viaduct (0.1 miles).

The expansion of the railways in the mid- to late nineteenth century would change the area forever. In 1860 the London, Chatham & Dover Railway reached St Mary Cray. Unlike at Orpington, the line was built right across the centre of the parish and town with this viaduct.

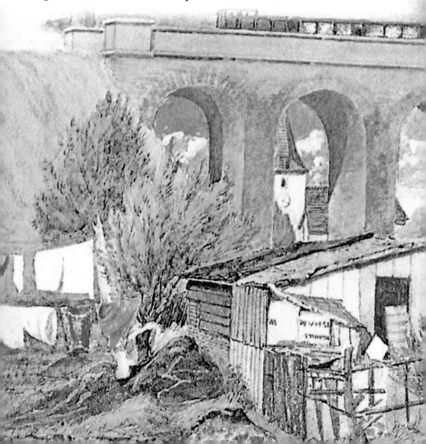

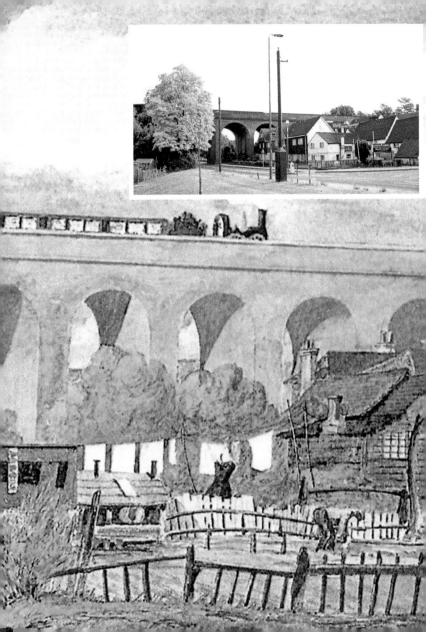

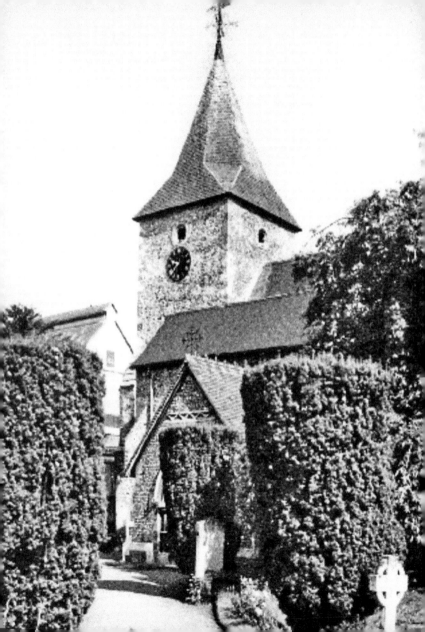

17. ST MARY THE VIRGIN CHURCH

Retrace your steps and walk south on Mill Bank Road/B258 towards Sandway Road (180 feet). Turn left onto Sandway Road (118 feet) then turn left onto High Street and continue north (0.1 miles).

This is St Mary the Virgin parish church, St Mary Cray, dating back to the mid-thirteenth century. Now in a quiet cul-de-sac created by redirecting through traffic, the church would have been flanked to the east by the busy, bustling St Mary Cray High Street and the west by the multi-mill powering River Cray. The church continues to serve the local community in the way it has done for the past 750 years. The whole area around this part of the High Street is quite rightly a conservation area. (Courtesy of the Lynn Sculpher Collection)

18. ST MARY CRAY HIGH STREET, LOOKING SOUTH

Walk north on High Street towards and past Station Road (157 feet).

They say a picture paints a thousand words and this applies to this one! The buildings to the left are very old and still remain today. The parish church is to the right. Today, each side of the original St Mary Cray High Street is a cul-de-sac. In the days when this old photograph was taken, the High Street was a very busy thoroughfare.

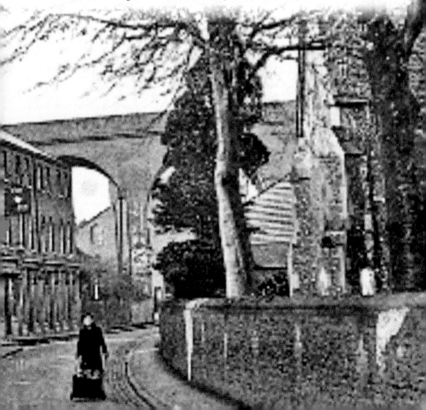

19. ST PAULINUS CHURCH

Walk north on Main Road towards and past Hearns Road (0.4 miles).

This ancient parish church has registers going back to 1580. The origins of the church go further back to Saxon times. St Paul's Cray was once part of the lathe of Sutton-at-Hone, hundred of Ruxley and within the Union of Bromley. It was an important part of the village. Sadly, the use of the church declined and the parish was withdrawn. However, a new chapter has begun with the Redeemed Christian Church of God reopening the church for religious worship. (Courtesy of the Lynn Sculpher Collection)

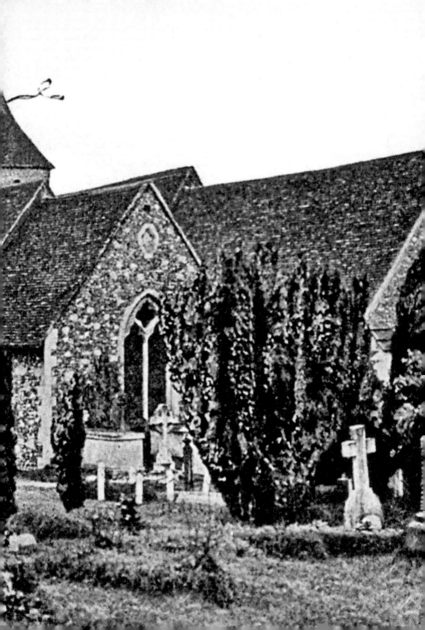

20. MAIN ROAD, ST PAUL'S CRAY

Walk north on Main Road towards and past Garden Cottages (340 feet).

Around 1900 St Paul's Cray comprised of St Paulinus Church, the Bull pub, a small number of dispersed houses, Coppice Wood, Gray's Farm, St Paul's Cray Hill, St Paul's Cray Common and a corn mill powered by the River Cray. This image shows the junction where the Bull pub is located – with St Paulinus this was the origin and focal points of the parish. It was an important point for travellers bound for Foots Cray, Sidcup, Bexley and Maidstone. The corn mill became Nash's Paper Mill. Coppice Wood, St Paul's Cray Hill and Gray's Farm would become housing estates following the Second World War housing boom.

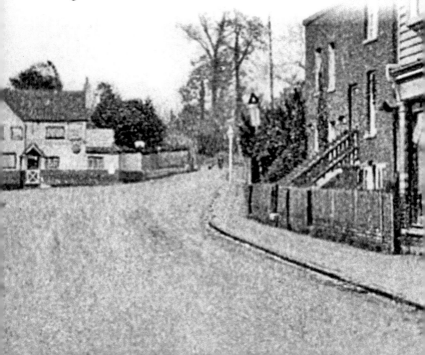

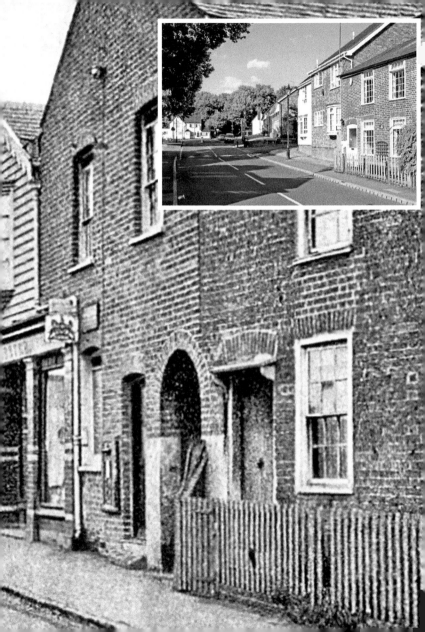

21. JOYNSON'S PAPER MILL

Retrace your steps and head south-west on Main Road past Garden Cottages and Hearns Road (0.5 miles). Turn right onto Station Road and continue to Sevenoaks Way traffic lights (0.1 miles). The mill was located on the left.

This is Joynson's Paper Mill in St Mary Cray. This huge mill was located where modern large retailers trade their wares today (on the north side of the railway embankment). Joynson's produced high quality paper and banknote paper. The mill closed in 1967 and was then demolished. It was a significant employer in the area and the chimney alone could be seen from a long way away.

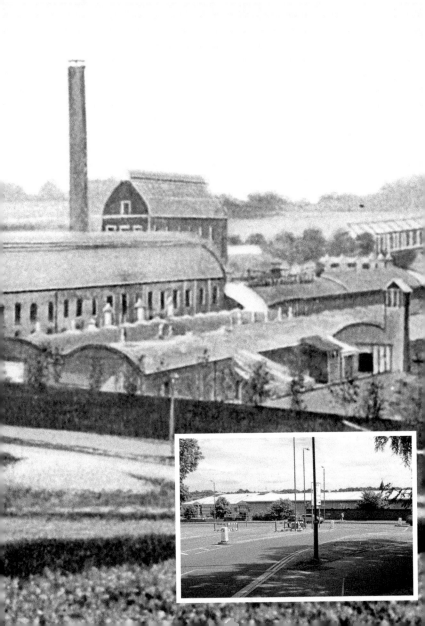

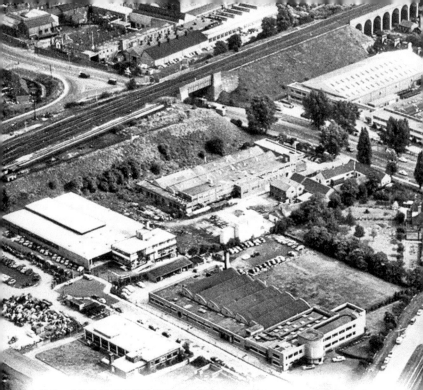

22. MORPHY RICHARDS FACTORY

Walk south along Sevenoaks Way/A224 to the Nugent shopping centre (0.2 miles).

Mr Donal Morphy and Mr Charles Richards had previously worked together, and on 8 July 1936 at Manor Farm, Market Meadow, St Mary Cray, 'Morphy Richards' started trading. The company, a household name nowadays and for decades before, established its headquarters and manufacturing premises at St Mary Cray. For nearly half a century, they were the biggest employer in the district. By 1970, production of goods moved to Swinton and Dundee.

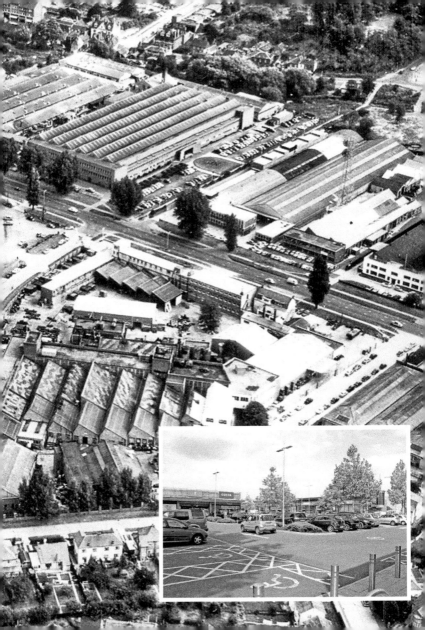

23. CARLTON PARADE

Walk south along Sevenoaks Way to Carlton Parade traffic light junction (0.8 miles).

The current 1920s shopping parade has a hidden history. Less than 100 years ago, this area was still very rural. The land of a large corn mill existed on the current site of Carlton Parade and the residential housing behind it. The mill was the first on the River Cray and had its own header ponds to maintain the power for the waterwheel. The parade of shops was also the location of the old former Palace Cinema and Smith and Millroy's workshops, where they built the Orpington Car.

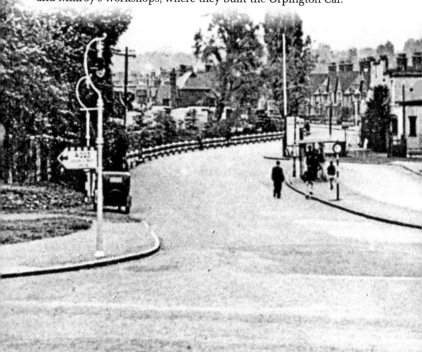

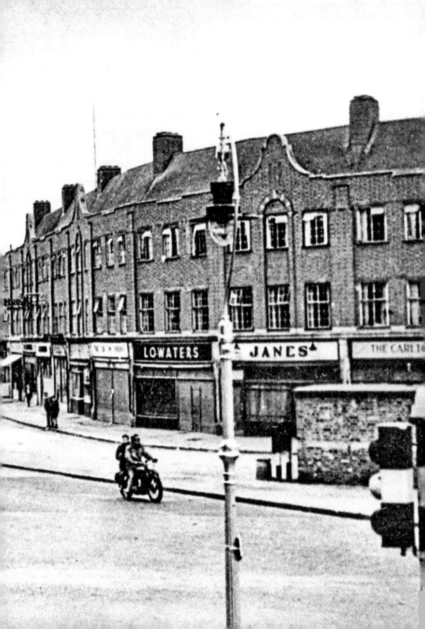

24. THE PRIORY PONDS

Walk south-west on High Street (300 feet).

The Priory ponds are the head and source of the River Cray. In years gone by, the ponds have had many uses. They were used to water livestock, fill bowsers for drinking water and for steam engines to take on water. In addition, water would power a number of large mills further down the river. Today, the ponds are the home of a healthy number of waterfowl. In the above image, the boys are possibly fishing for sticklebacks where the water flows under the road to become the River Cray.

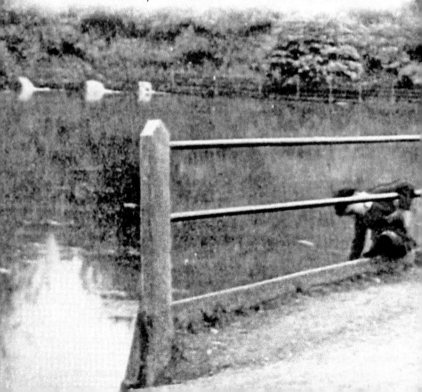

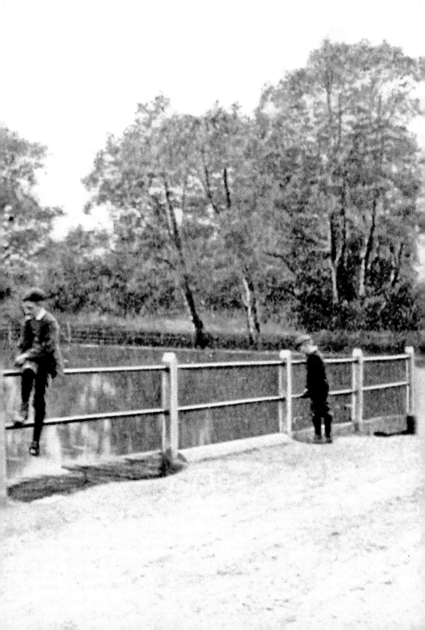

25. THE ARTICHOKE

Walk south-west along High Street past Church Hill (0.3 miles).

Orpington had many public houses, inns and associated hotels. Many of them survive. Here is the Artichoke, built around 1855. It existed with the White Hart, the Change of Horses, the Cricketers and the Anchor & Hope for years. Each offered something slightly different for their clientele. Today, the building still stands as a successful Turkish restaurant. (Courtesy of Bromley Local Studies Department)

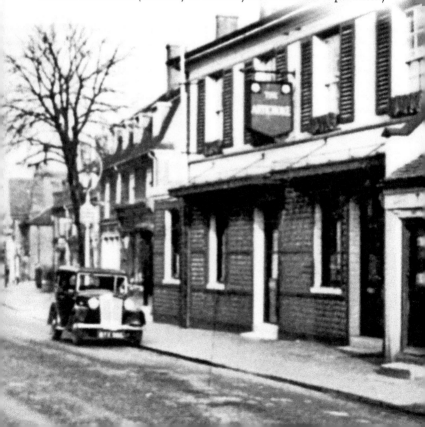

26. VILLAGE HALL

Continue south along High Street (160 feet) to Nos 115–123 High Street.

Designed by George St Pierre Harris and given to the villagers in 1890 by the late Alfred Brown Esq, the village hall and social club (seen to the right) were central to the village. The hall hosted numerous events including weddings, exhibitions, formal meetings and social events, until a serious fire devastated the building in 1961. The social club (previous home of the Liberal Club) survived until the early 1980s when it, and the derelict village hall, were flattened and the modern Templegate complex was built.

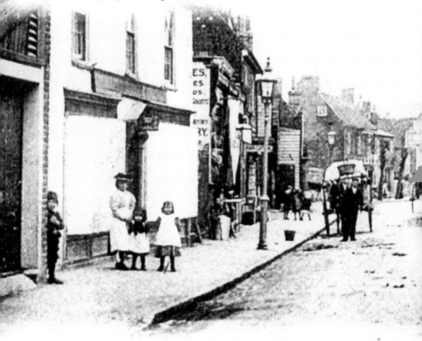

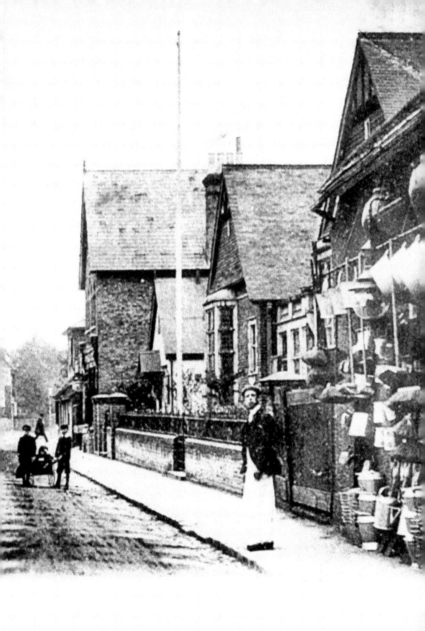

27. THE OLD COTTAGES

Continue south along High Street (400 feet) to No. 171 High Street.

Believe it or not, these two cottages were some of the oldest existing buildings in Orpington, going back to the early seventeenth century. They were located close to the previous image. The wall to the left was that of Mayfield Place. You may be surprised to know that they were demolished in 1938 in the name of progress! If they had survived to this period, they would surely have been a cherished attraction to the High Street. (Courtesy of the Jean Bodfish Collection)

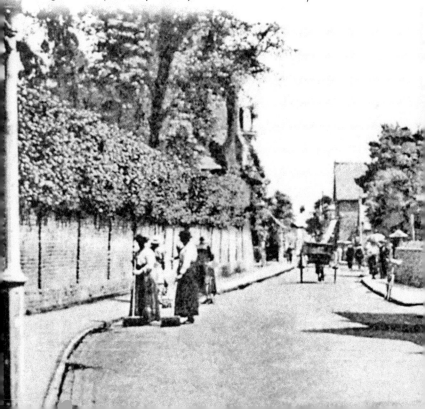

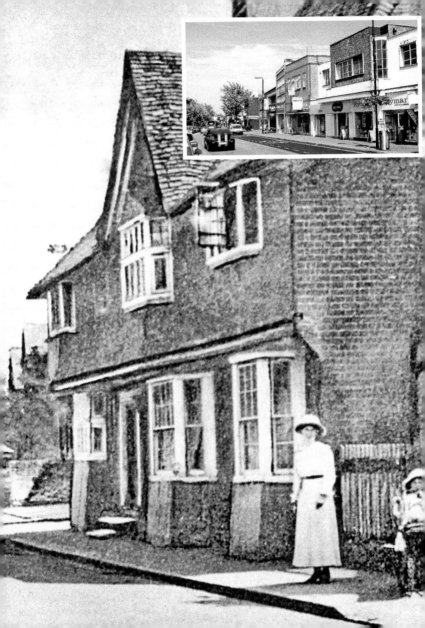

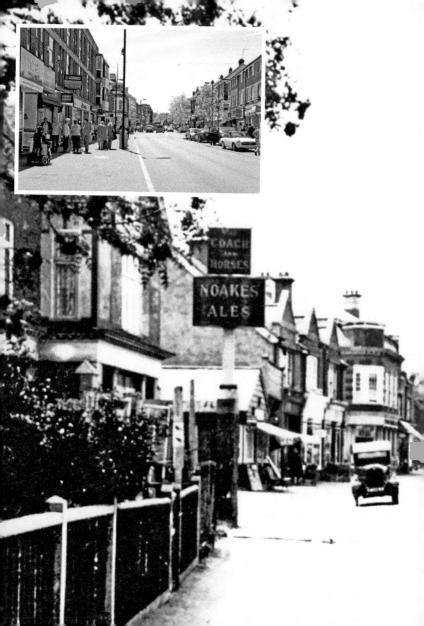

28. COACH & HORSES

Continue south along High Street (0.1 miles) to No. 225 High Street.

This view has changed significantly since it was taken in 1920. We are looking south along the High Street with Homefield Rise on the left. The only building recognisable here now is the NatWest Bank premises on the corner. The word 'home' was typically applied to a 'farm' or 'field' where a large residence, such as a manor house, had its own farm. The land on which Homefield Rise and its housing estate was developed originally belonged to Gravel Pit and Court Lodge farms, which have long since disappeared.

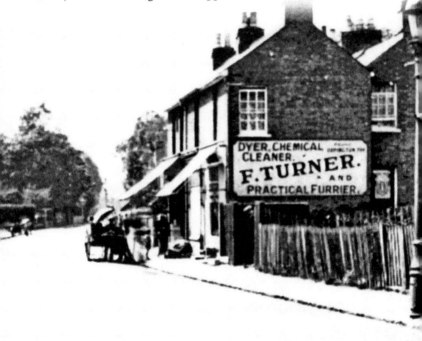

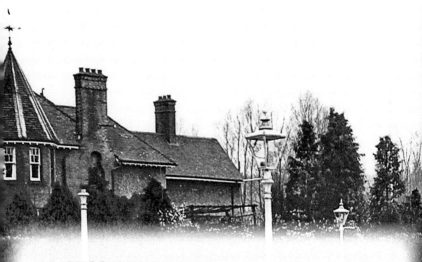

29. WAR MEMORIAL

Continue south along High Street to the war memorial (0.2 miles).

One of Orpington's most iconic landmarks. The war memorial, or cenotaph, reminds thousands of residents and passers-by of Orpington's patriotic involvement in conflict at a time when Orpington, as a village, was emerging into the modern era. The memorial was unveiled on Sunday 28 August 1921, designed by Charles Heaton Comyn. The original road junction was just three roads: High Street, Station Hill (later Road) and Sevenoaks Road. The memorial has three lions facing each of the original roads, with Spur Road coming later on.

Walk west up Station Hill/A232 and turn right into Station Approach (0.4 miles) and you will be back at Orpington railway station.

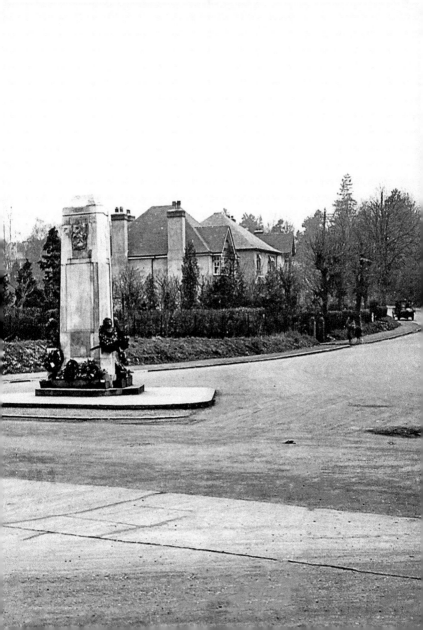

TOUR TWO
30. BOUNDARY GARAGE AND
SE RAILWAY 'TRIUMPH ARCH'

From the railway station, walk south on Station Approach to Station Road/A232. Turn left onto Station Road/A232. Turn right into Tower Road and continue downhill onto Sevenoaks Road/A223 (0.3 miles). Turn right and continue south along Sevenoaks Road to the petrol station (371 feet).

The Boundary Estate existed long before the railway sliced through it in 1868, and was so named because the estate and farm sat on the boundary between Orpington and Green Street Green. In later years, the owners of the Boundary Estate gave a huge amount of land to the Ontario government, which became Orpington Hospital. Boundary Garage will be located on the left, with the South Eastern Railway's 'Triumph Arch' spanning the main road from Orpington to Green Street Green (Sevenoaks Road). At the time, it was the largest hand-built brick-road tunnel in the south.

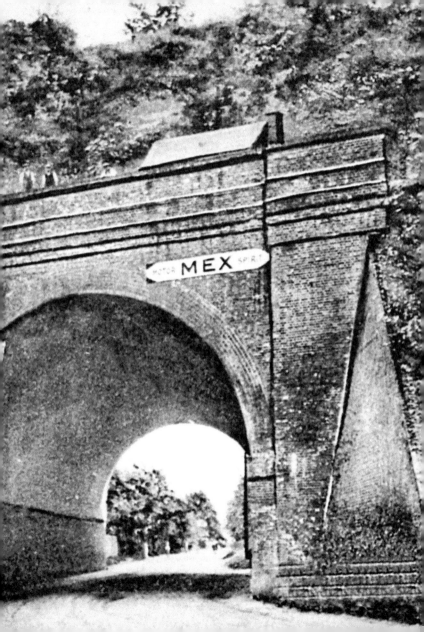

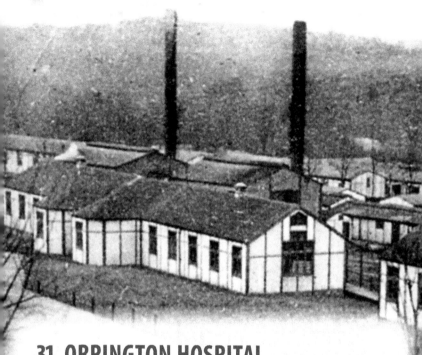

31. ORPINGTON HOSPITAL

Continue south along Sevenoaks Road under the railway arch and turn left into Cardinham Road (0.1 miles). Walk uphill to the mini-roundabout and turn right (0.1 miles).

The Ontario Military Hospital was built on the Boundary Estate by the Ontario Canadian government in February 1916. The hospital served the Commonwealth soldiers of the First World War. By 1919 it was known as '16th Canadian General' and over 15,000 wounded soldiers were being treated here. The Canada Wing, Orpington Hospital, was opened in 1983 and is the only reminder left of a vast hospital that served the Commonwealth and became a civilian hospital serving the area for many years.

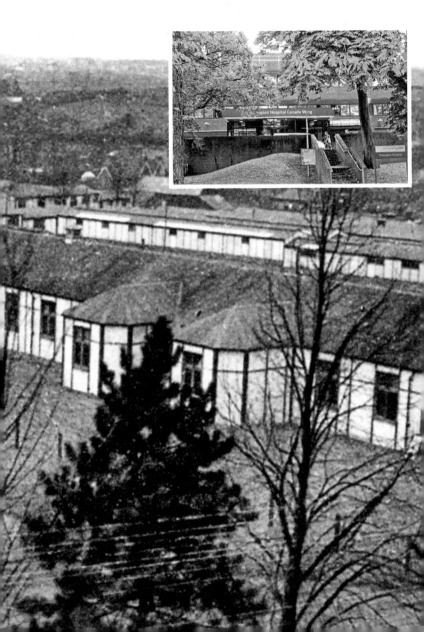

32. THE CRESCENT

Return to Cardinham Road and walk downhill to Sevenoaks Road (0.1 miles). Turn left (south) and continue along Sevenoaks Road (0.3 miles).

This crescent-shaped double parade of shops was built as part of the Davis Estate that surrounds the immediate area. The residential development was started in the 1930s and completed after the Second World War. During the war, a number of half-built properties and roads were simply left until they could be completed. This is why the estate has two distinct styles of housing, from the 1930s and the 1950s.

33. FARNBOROUGH BYPASS CROSSROADS

Walk south along Sevenoaks Way (just past The Buff) and turn right into Shire Lane (400 feet). Continue along Shire Lane to Garnborough Way/A21 (0.2 miles).

This junction was created as a result of the construction of the bypass. Originally, Shire Lane continued to Sevenoaks Road and to a junction with Warren Road. Farnborough Hill continued into the part of Farnborough Hill that leads into Green Street Green. The junction would be attended by an AA Officer directing traffic by hand signals. Imagine how effective this junction marker would have been in the dark or bad weather! (Courtesy of David Daws)

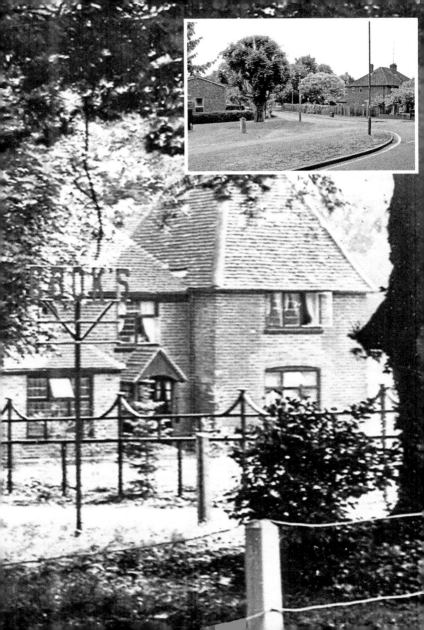

TOUR THREE: FURTHER AFIELD
39. FIVE BELLS, CHELSFIELD

As this tour ventures further afield, a vehicle is recommended. Postcode: BR6 7RE.

We are so lucky that, as shown in this view of Chelsfield village's pub, *c.* 1907, many of the typical scenes of villages within the district have not changed all that much. Chelsfield ecclesiastical parish was originally of considerable extent, including the hamlet of Pratts Bottom and part of Green Street Green. The building of the Orpington Bypass (Court Road) in the 1920s unfortunately cut off the church and the court lodge from the village. (Courtesy of the Jean Bodfish Collection)

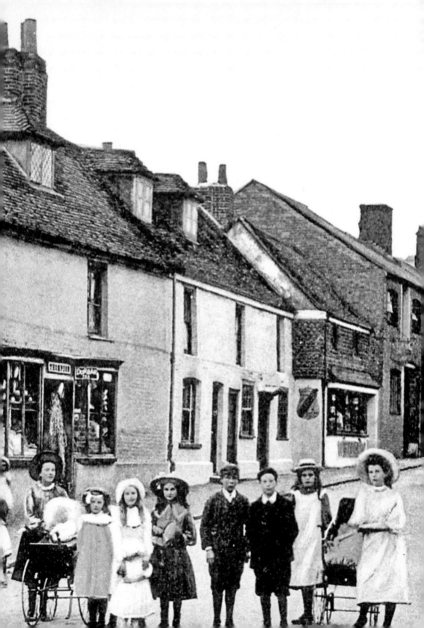

40. HIGH STREET, CHELSFIELD

Postcode: BR6 7RE

This is a well-known image of a line-up of local children, taken around 1908, in an unusual coloured version. This style of colouring cost the shopkeeper a little more but gave him an edge over competitors. In those days, postcard messages were the equivalent of email today; when Royal Mail had many collections and deliveries, postcards often took just a few hours to be delivered. (Courtesy of the Jean Bodfish Collection)

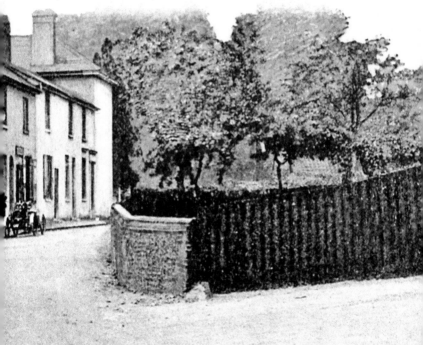

41. FOX & SON OAK BREWERY, GREEN ST GREEN

Head south-west on Church Road towards Court Road/Orpington Bypass. Turn left onto Court Road and at Hewitts roundabout take the fifth exit onto Sevenoaks Road. At Pratts Bottom roundabout take the second exit and stay on the A21. At Green St Green roundabout take the third exit and continue along High Street until Superior Drive on the left. Postcode: BR6 6BG.

In 1818, John Fox moved to Green Street Green to run Oak Farm and, as was common, grew his own hops and grain to produce ale for family use, selling the excess to the Lubbock family. Encouraged by Sir John Lubbock, John Fox started brewing commercially and by 1836 Oak Brewery produced ale. Business boomed, the brewery expanded, and local pubs proudly displayed the Fox name. The Fox family contributed hugely to the development of Green Street Green and the welfare of its residents, many of whom were employees. Foxes ceased trading in 1909 and the huge brewery was ultimately demolished. The last factory on the site used the brewery perimeter wall as its own, as well as the huge cellars and chambers underground. All buildings were finally demolished and filled in. A pleasant housing estate now exists on the land. (Courtesy of Bromley Local Studies Department)

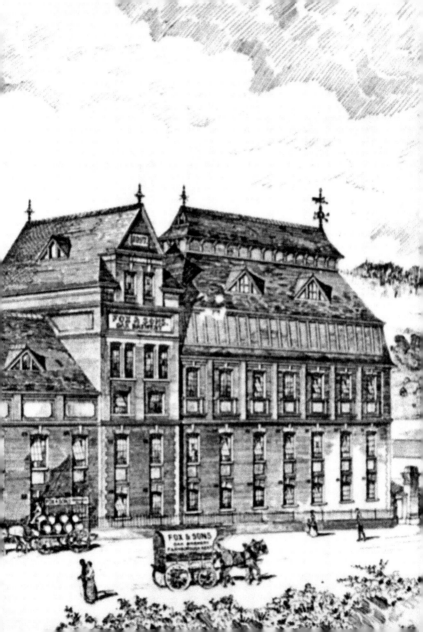

42. HIGH ELMS HOUSE

Continue north along High Street (0.1 miles). At the roundabout take the first exit to Farnborough Hill/B2158 and continue to the A21 roundabout (0.1 miles). Cross, and continue along Farnborough Hill for a short distance to Shire Lane mini-roundabout, then turn left into Shire Lane. Continue along Shire Lane until High Elms lane is on the left (0.5 miles). Turn into High Elms Lane and a public car park is on the left. There are information boards explaining where the house was located. Postcode: BR6 7JH.

From the early nineteenth century High Elms House and Estate belonged to the Lubbock family. In 1865 ownership passed to Sir John William Lubbock (4th Baronet and 1st Lord Avebury). His prestigious philanthropic, scientific and political careers and friendship with Darwin made him and High Elms famous. We have him to thank for the Bank Holiday Act of 1871! The Lubbocks sold the house in 1938, which burned to the ground in 1967. Today the estate is a popular recreation and education centre.

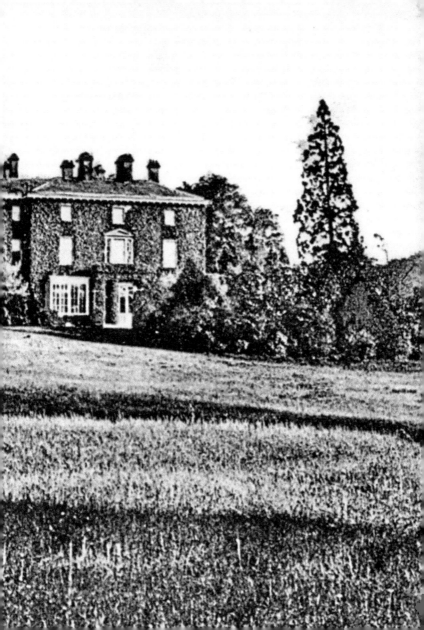

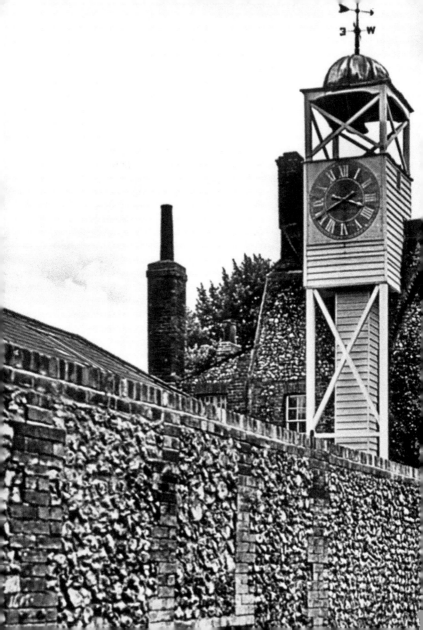

43. CLOCK HOUSE FARM, HIGH ELMS

Turn left onto High Elms Lane (in the direction of Downe) and continue past the golf course entrance (0.4 miles).

This is one of the original nineteenth-century buildings of the original High Elms Estate, and here is the farmhouse of what is now called Clock House Farm. In 1826 the clock and bell were constructed to give a visible and audible call to the workers to mark the start and end of the working day and meal times.

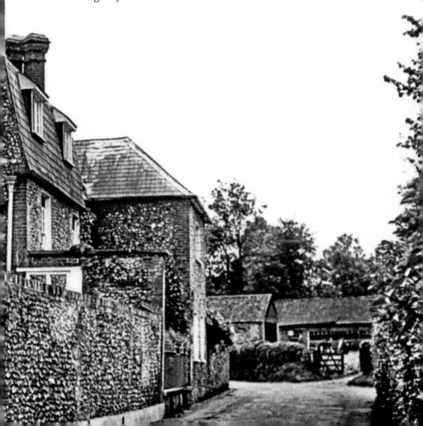

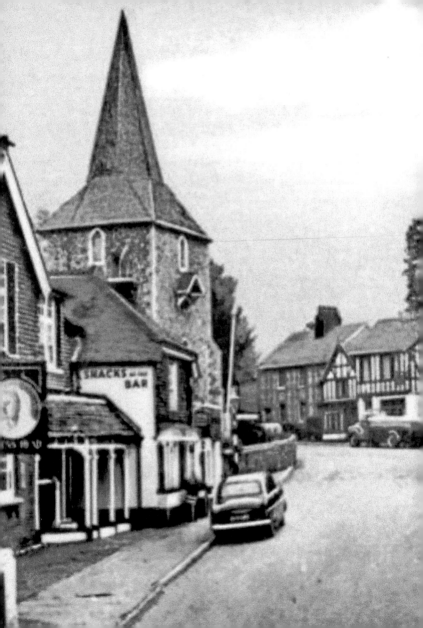